GW00578255

James in Space

by
Helen Farrugia

leaf publishing house

This book is dedicated to my son James who gave my life meaning and has inspired me to use his imagination to write these stories.
You are a special boy and you will achieve great things in life.
Just remember you've got this, baby boy.
I'm so proud of you.
All My Love — Mum X

this book belongs to:

James was a very special boy and just like you he had an amazing super power which would allow him to go anywhere and be anything he wanted to be, and today James wanted to be an astronaut. So he pulled on his spacesuit and his cardboard helmet and jumped into his cardboard spaceship and began the countdown to blast off.

"5.4.3.2.1 BLAST OFF!!!!"
James shouted with delight.

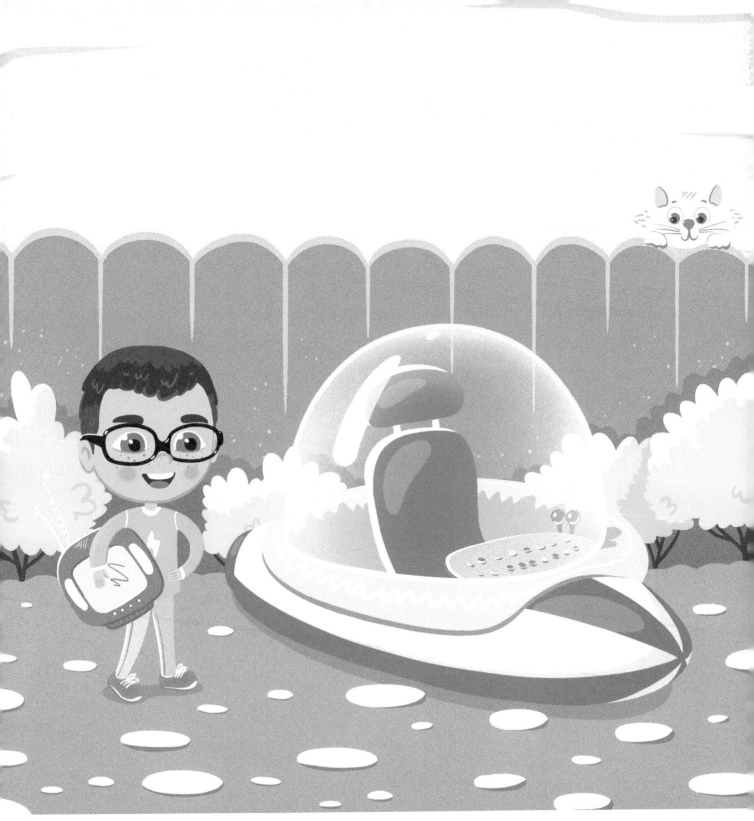

Suddenly James found himself rocketing into space,
higher and higher he went until he could reach the stars.
James looked around and he was amazed at what was around
him, he could see a million stars shining brightly, he could see the
planets, the sun and the big bright beautiful moon. James could see
a little house on the moon so off he went to investigate who lived in
the little house on the moon.

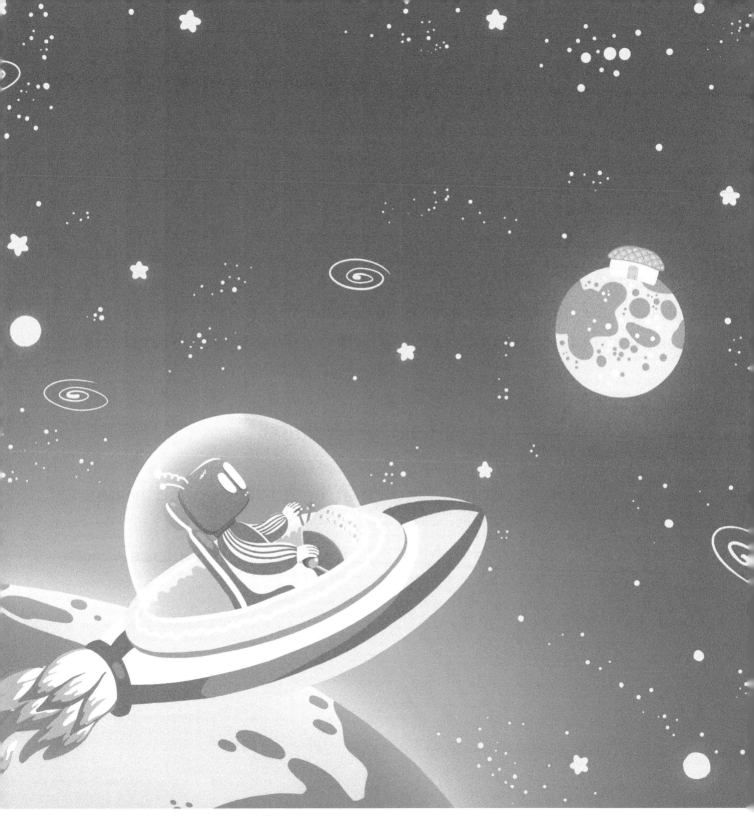

James landed his spaceship on the moon next to the little house. He climbed out of the rocket and went to the door of the odd little house and gave a big brave knock on the door. The door began to open slowly and a green face with yellow eyes peered round the door and said

"Hello who's there?"

"My names James and I'm from earth" replied James.

"My name is Alex the alien" replied the face.

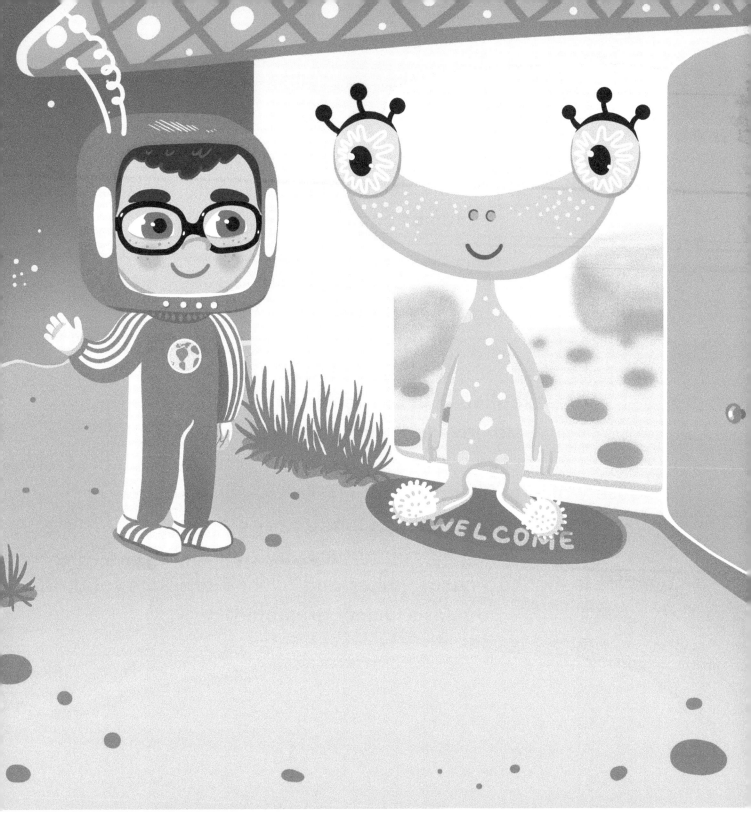

Alex the alien opened the door wide so he could see James and James could see him.

"Would you like to come in for some space tea?"
Alex asked.

"Oh yes please"
James replied with excitement and in he walked
to have tea with Alex the alien.

The house was brightly coloured and had a bright yellow floor with purple polka dots on that you could jump on
"this way" said Alex the alien. James followed Alex to a bright blue table that had cakes, jellies and all kind of space food on.
James's tummy grumbled.

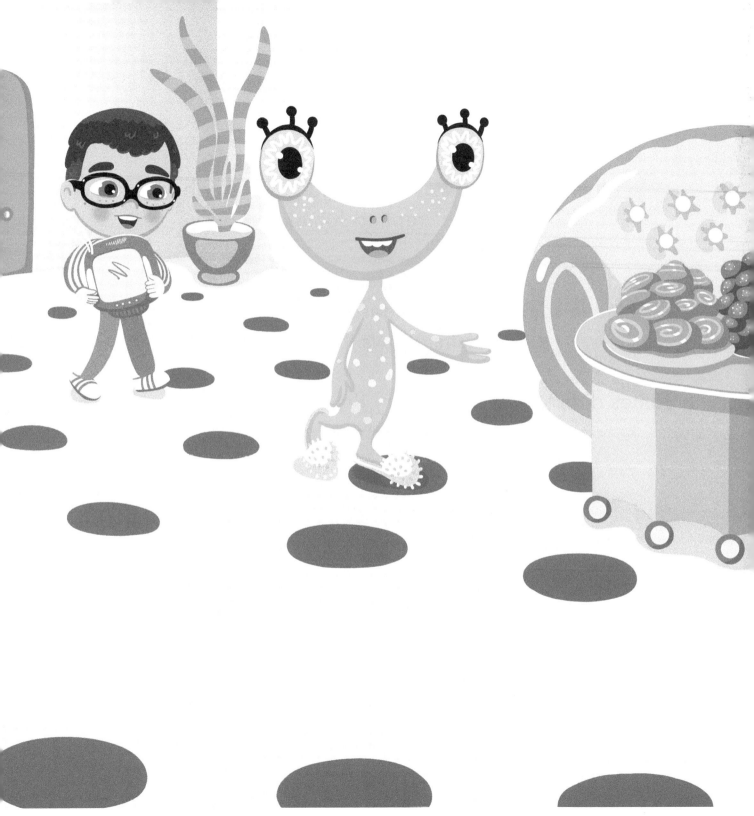

"Are you hungry?"
asked Alex

"I'm starving, it was a long ride from earth to here."
replied James.

Alex said
"Here have some galaxy gingerbread or you could try the meteor
marshmallows if you want to."

James didn't know what to try first so he had some gingerbread
and some marshmallows

"mmmm delicious"
said James rubbing his tummy.

"Would you like some Comet Cola?"
Asked Alex handing James a cup.

Once James and Alex had finished all the
yummy treats they played space chase.

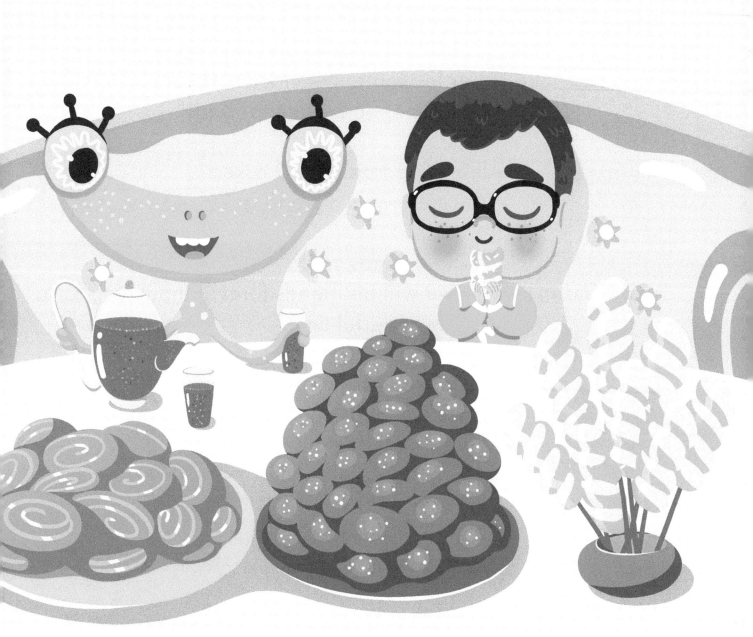

Alex and James bounced around the house on the polka dots
chasing each other for hours and hours,
then James looked at the clock and said
"Oh no I'm gonna be late for bed!"

Alex looked upset and asked
"You mean you have to go?"

James said
"Yes, but don't worry we will be friends forever thank you for a
wonderful time."

Alex looked at James and said
"Yes we will be friends forever."

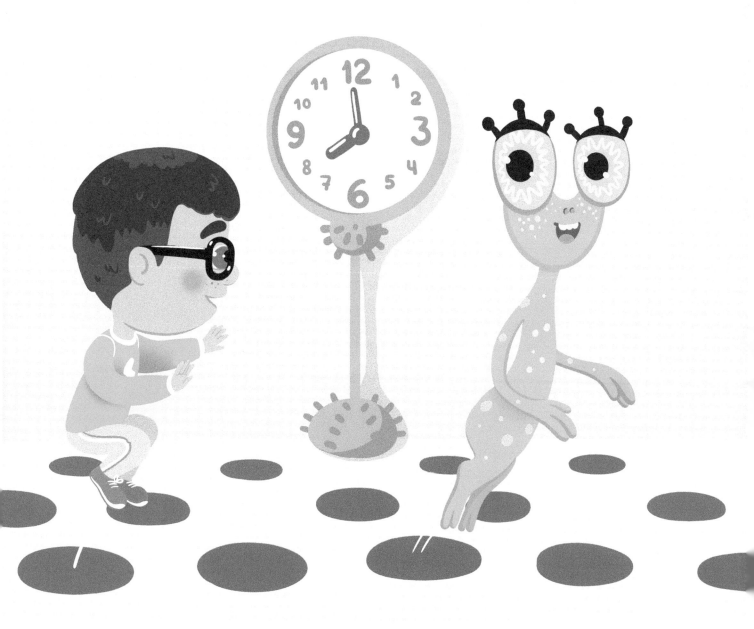

James left the odd little house and climbed back into his spaceship
and began the countdown
"5.4.3.2.1 BLAST OFF!!!!"

James looked at the little house and saw
Alex waving his tentacle

"Goodbye Alex!"
James waved back.

"I'll never forget you."
James said.

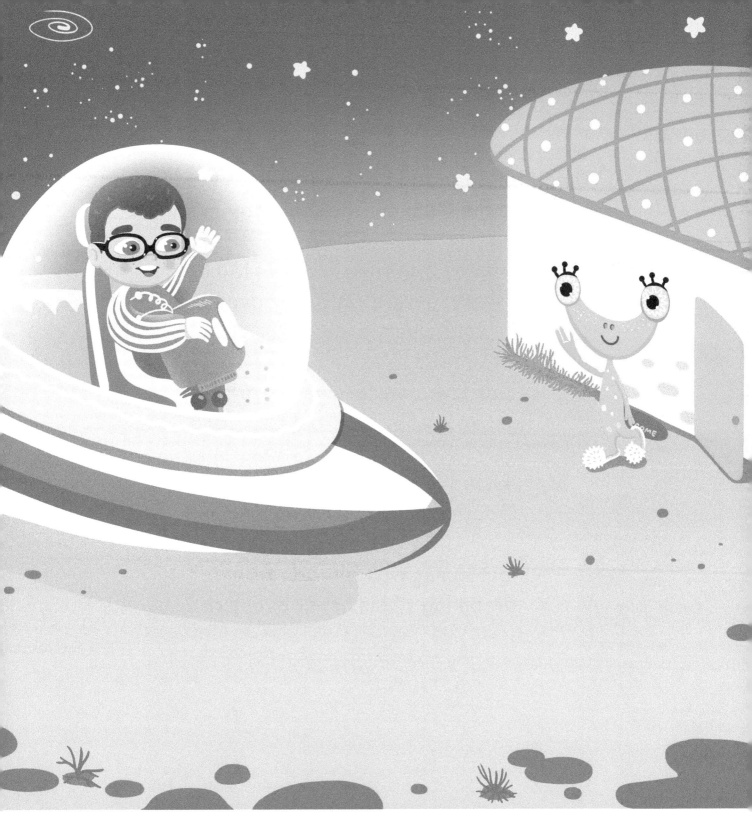

When James landed back home he rushed inside
and told his Mum all about his day in space.

"I can't wait for tomorrow Mum,
I'm going to have another adventure"
said a very sleepy James.

"That's wonderful sweetheart, but
right now you need to go to sleep"

Mum kissed him on the forehead and said
"Goodnight James sweet dreams"

but James was already asleep,
dreaming of his next adventure.

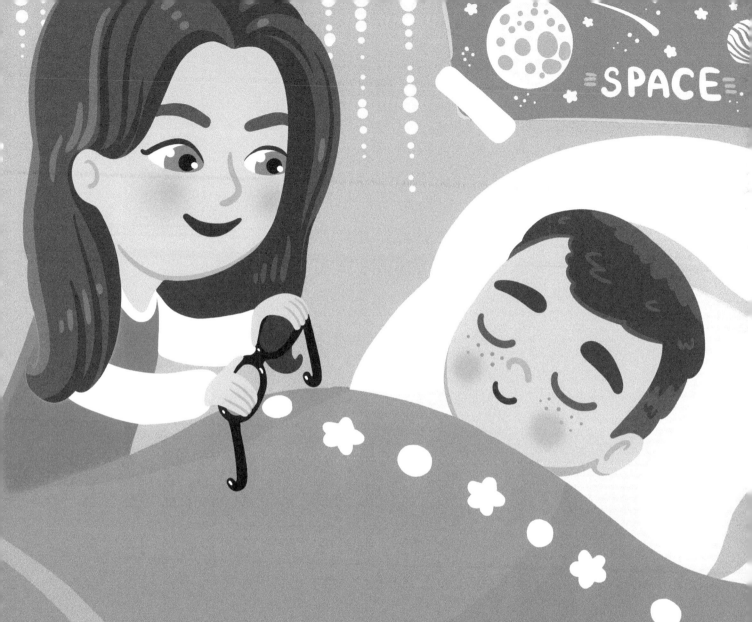

the end

acknowledgements

I'd like to acknowledge my husband John for supporting me throughout this amazing journey, I couldn't have done this without you hunny. I'd also like to say a very special thank you to the best father in law Terence pope I could have ever asked for without you my dream wouldn't be a reality thank you dad for everything I love you x I'd also like to thank my close friend Kayleigh Tomlinson, who always always pushed me to believe in myself. Finally I'd like to thank Enid Blyton who filled my childhood with amazing stories she was my hero and it is because of her I wanted to be a writer.

I'd also like to say a very special thank you to the best father in law Terence pope I could have ever asked for without you my dream wouldn't be a reality thank you dad for everything I love you x

In memory of Betty Pope.

The best mother in law I could have ever asked for, no
matter how bad things got, she would always smile and tell me
"You've got this I believe in you."
Thank you for always giving me the strength I so badly needed and
for always having my back I miss you. x

coming soon:

james and the octopus

james and mister moneky's race

james and the jungle

james and the pumpkin

james' magical christmas gift

James in Space
First Edition
Copyright Helen Farrugia © 2020

All Rights Reserved
No part of this publication may be reproduced
without written permission from the author.

ISBN: 978-1-9163098-0-7

Lightning Source UK Ltd.
Milton Keynes UK
UKHW050058010720
365813UK00006B/248

9 781838 033125